KING'S LYNN
THROUGH TIME
Paul Richards

AMBERLEY

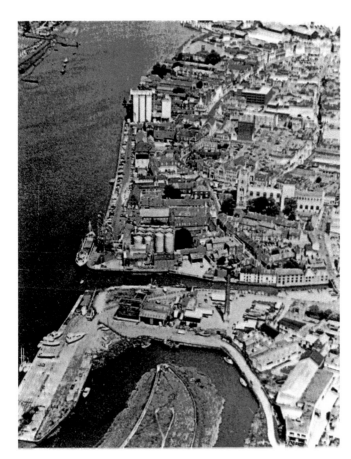

Lynn, c. 1985
This aerial view shows Lynn's elongated Old Town alongside the River Great Ouse. Here riverside streets and two market places retain an impressive number of historic buildings, but twentieth-century grain silos by the waterside are prominent. Since the 1990s, these tall structures and other industrial premises have been demolished. The North Sea Haven or Millennium Project began the regeneration of the South Quay and riverside.

First published 2014

Amberley Publishing
The Hill, Stroud, Gloucestershire, GL5 4EP
www.amberley-books.com

Copyright © Paul Richards, 2014

The right of Paul Richards to be identified as the
Author of this work has been asserted in accordance with
the Copyrights, Designs and Patents Act 1988.

ISBN 978 1 4456 0837 2 (print)
ISBN 978 1 4456 3571 2 (ebook)

British Library Cataloguing in Publication Data.
A catalogue record for this book is available from the
British Library.

Typesetting by Amberley Publishing.
Printed in Great Britain.

Introduction

In the century or more following the 1086 Domesday Book, the hamlet then called 'Lena' was transformed. When Lynn (as in local parlance) received its first royal charter of borough freedom in 1204 granting its merchants some independence from the Norwich bishops, it was already the third or fourth port of the Kingdom. But the town remained 'Bishop's Lynn' until 1537, only becoming 'King's Lynn' with the assistance of Henry VIII. Salt, corn, ale, fish, wax, furs, wool, cloth and timber, carried by home and foreign ships, had generated its wealth. The churches, guildhalls, town defences and friary remains tell of the medieval status and significance of Lynn.

Lynn was a prominent port in the Middle Ages and later depended on an extensive hinterland embraced by the Great Ouse and its tributaries, linking the Norfolk haven by water to Ely, Cambridge, Bury, Bedford, and other inland towns. Its privileged geographical position on England's East Coast promoted the coastal trade in corn and coal, which thrived until it was undermined by the railways in the 1840s. Yet international seaborne commerce had been substantial since the twelfth century; Iberian and French wine as well as Baltic timber were still valuable imports in 1750. Corn was now Lynn's major export, rather than the wool and cloth that had attracted Hanseatic merchants from the North German cities like Lübeck before 1500.

Though East Anglian ports played a forward role in England's Industrial Revolution (1750–1850), sending both migrants and foodstuffs to the expanding northern manufacturing districts and London, Lynn went into relative decline in the nineteenth century. Its population merely doubled from 10,000 to 20,000 as the railways robbed the Wash port of its geographical advantages. But docks and railways together launched a modest first Industrial Revolution around 1870 in an arc around the old town, with engineering factories and artificial fertiliser plants most noteworthy. Moreover,

the Port of Lynn revived its coal and timber traffic once the two docks became operational. Lynn's economy was partly sustained by its role as a regional market town and fishing harbour.

Even in 1950, Lynn had just 25,000 inhabitants, and the prospect of stagnation in the twentieth century motivated both local and central government to plan a second Industrial Revolution. New suburban industrial estates and a rising town population were the result of the overspill agreement between the borough council and the Greater London Council in 1962. The electrification of the railway line between Lynn and London in 1992 was another important event. The North Sea Haven or Millennium Project was designed to regenerate the Ouse waterfront, and this continues to be a priority for the Borough Council.

Despite town centre redevelopment in the 1960s, Lynn can justly claim to be a historic town of national significance, with its exceptional series of riverside streets and their merchant houses and warehouses.

Using nearly 200 images covering over 150 years, along with commentary, this book will unfold Lynn's river, trade, buildings and people.

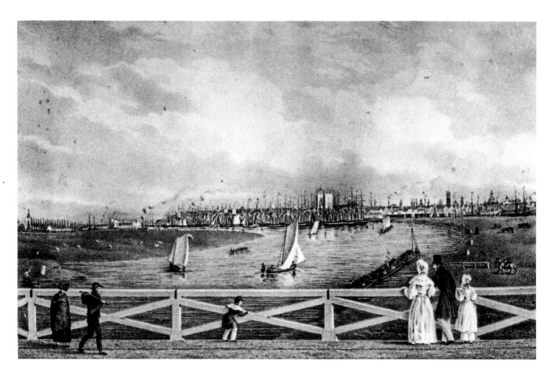

Lynn Harbour, 1841
This view from the bridge built in 1821 over the new Eau Brink Cut shows a forest of masts with ships unloading coal, timber and wine. Wheat and barley were exported coastwise and overseas in great quantities. Apart from the fishing boats at Boal Quay, the Ouse is now much less busy. All merchant ships are accommodated in the two docks to the north, closer to the sea.

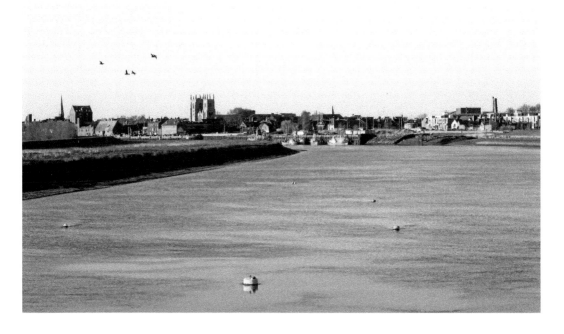

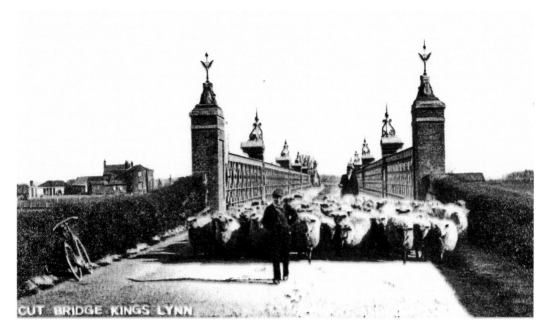

The Cut Bridge, c. 1900 and 1965

Road and railway bridges across the Ouse at Lynn have acted as gateways into East Anglia from the Midlands and the North. The wrought-iron bridge erected in 1873 replaced the original wooden structure. This was followed by a new Cut Bridge, which opened in 1925 at a cost of £28,000. Its reinforced concrete bowstring arches were a distinctive local feature, but it closed for safety reasons in 1969. Yet another new bridge was constructed for £235,000 and was operational by 1970.

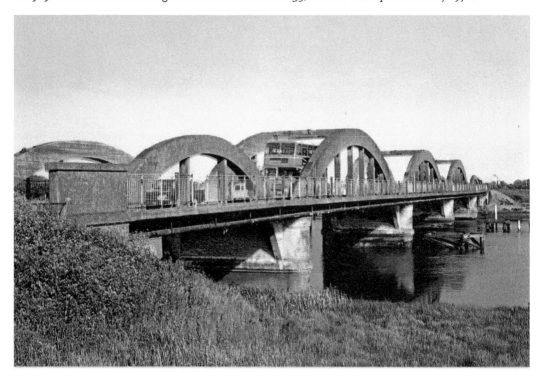

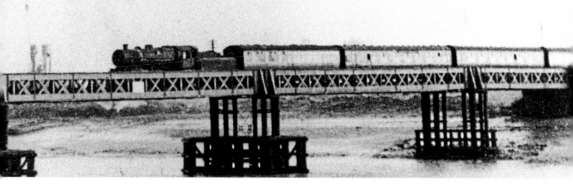

The Last Train to Leicester, 1959

Lynn's second railway station was established in 1862 at South Lynn to connect the town with the Midlands and the North. Here, the last train to Leicester can be seen slowly crossing the bridge (built in 1866) before the station closed in 1959. Its position is taken by the modern road bridge that carries Lynn's southern bypass across the Ouse, while local traffic uses the 1970 crossing.

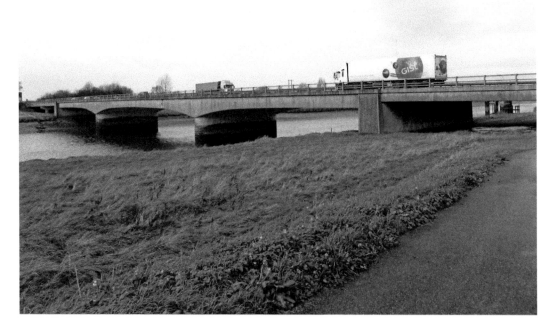

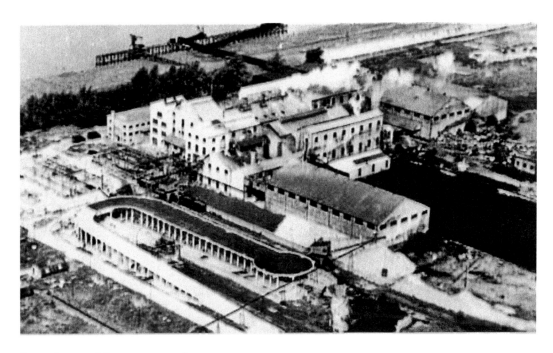

Sugar Beet and Paper, 1933 and 2013

Sugar beet cultivation after 1918 led to the building of several processing plants near East Anglia's towns. The Lynn factory was erected in 1927 beside the Ouse, where a jetty allowed crop delivery by barge. Its closure in 1994 was a 'blow to the community'. In 1997, the site was cleared and later became an ideal location for Palm Paper Ltd. The German parent company decided to build a £400-million paper mill at Lynn and production commenced in 2009. This is a recycling plant. Thousands of tons of waste paper are transported to Lynn on a daily basis, while sixty or more lorries leave Palm Paper with loads of newsprint to feed the presses of various newspaper groups.

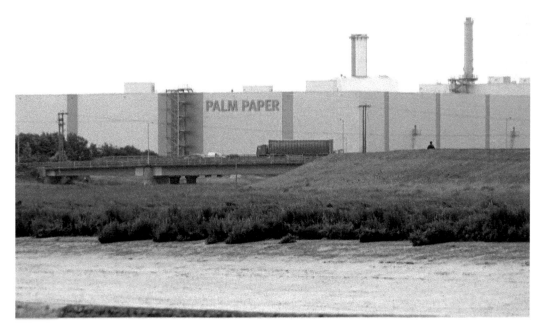

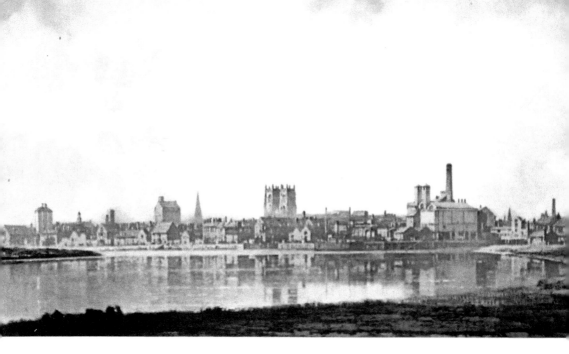

A View Exceptional and Arresting, 1949

Walter Dexter (1876–1958) captured the mood and character of the historic Wash port through his panoramas of the Ouse waterfront. Modern industrial buildings are juxtaposed with Lynn's medieval edifices in this view loved by the artist. Today's townscape from Dexter's favourite location reflects riverside redevelopment, but the twin towers of Lynn Minster remain dominant.

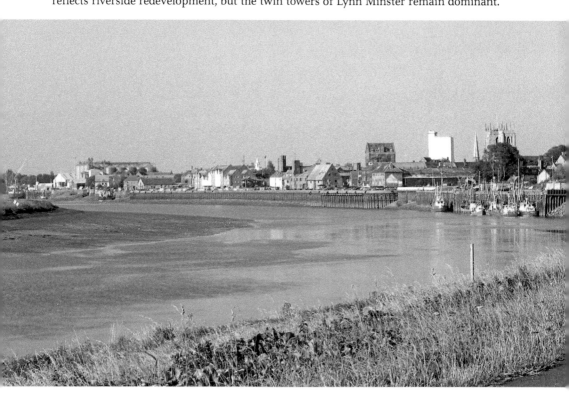

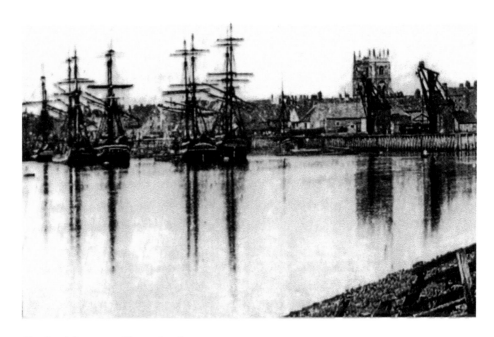

The Boal Quay, c. 1880 and 1965

Despite the construction of docks to the north of the town in 1869 and 1883, the river continued to harbour merchant ships. Sailing vessels were not outnumbered by steamships until the 1880s. To the right above are the two steam cranes that loaded ships with coal transported from the Midland counties for export to Europe. In the 1960s, the Boal Quay was still a working part of the Port of Lynn with its two great cranes.

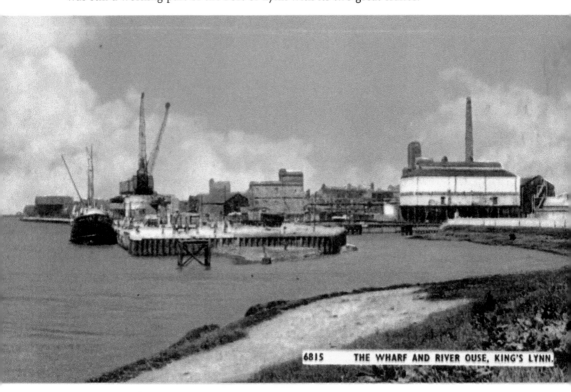

6815 THE WHARF AND RIVER OUSE, KING'S LYNN.

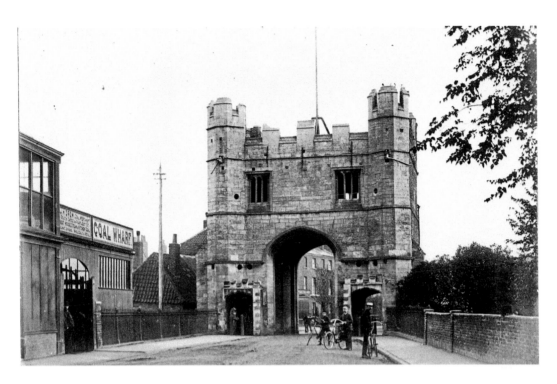

The South Gate, *c.* 1890

The South Gate was rebuilt in brick in the fifteenth century, and received a stone front in 1520. It accommodated a keeper in the eighteenth century to tax wagons. The road was widened to facilitate increasing traffic movement in 1899. The South Gate remains a major entry point, generating an appropriate sense of arrival into a historic town.

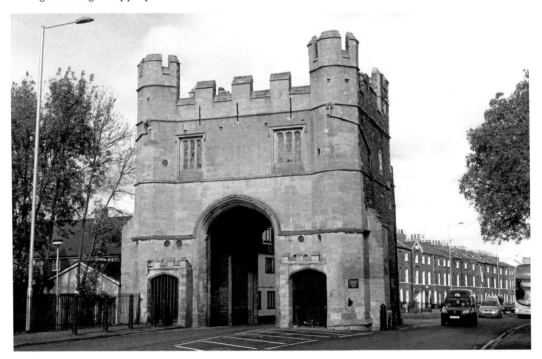

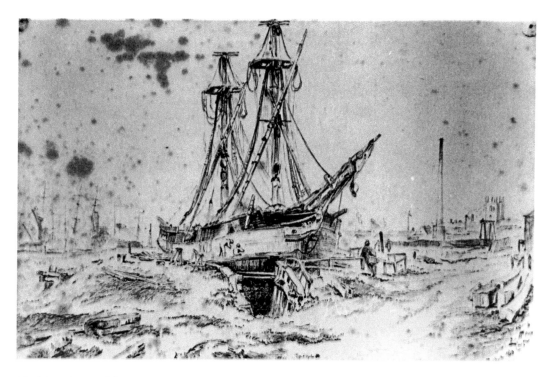

Maritime Lynn, 1862

The Friars area was the home of master mariners and sailors as well as shipbuilders. In the drawing by Henry Baines above, a vessel is being repaired in a dry dock. It was rented by William and Thomas Bagge from 1803 for sixty years, but it had been infilled by 1900. Friars Field provided allotments before Whitefriars Church of England School opened in 1971.

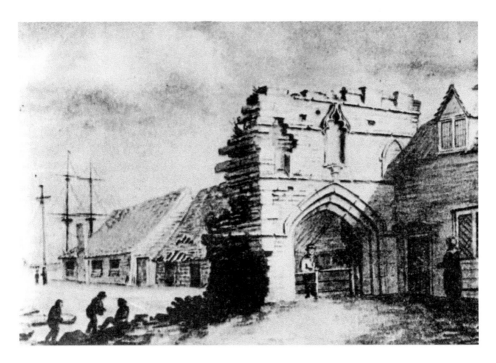

A Monument to Lynn's Whitefriars, *c.* 1810

This fifteenth-century brick gate was the northern entrance to Lynn's Carmelite house, which closed in 1538 when only ten friars remained. Today, the medieval structure is an isolated historic monument to a once thriving religious community, but local street names tell of its significance.

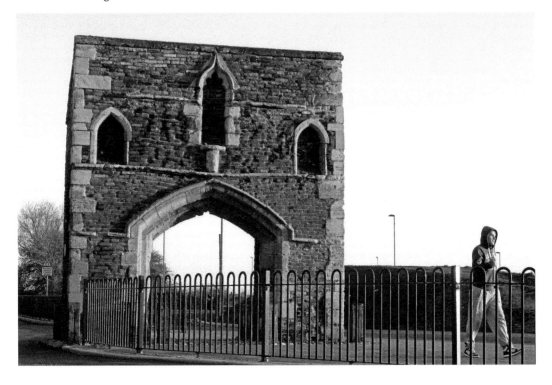

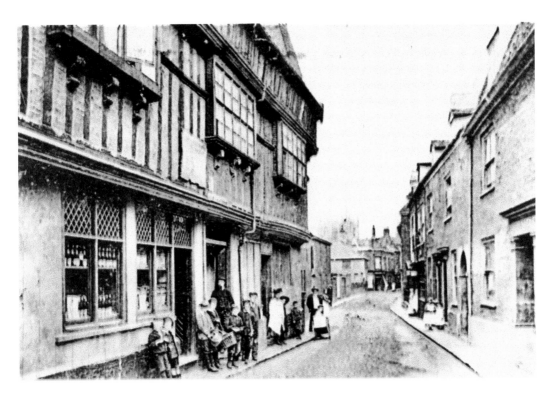

Greenland Fishery, Bridge Street, c. 1910

An impressive brick and timber-framed house erected by John Atkin in 1605. In the eighteenth century, this fine Jacobean mansion became a tavern and was renamed Greenland Fishery in 1796 to confirm its association with sailors from Lynn's whaling ships. A museum was established in the building in 1912. Bomb damage in 1941 led to its post-war restoration and it later came into the possession of the King's Lynn Preservation Trust.

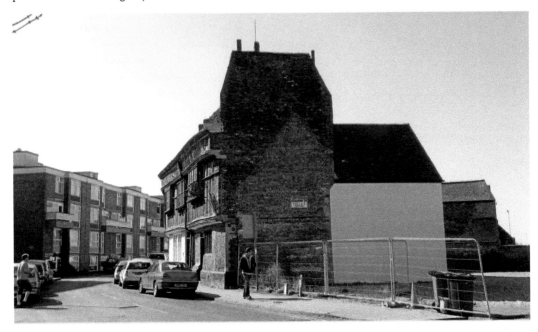

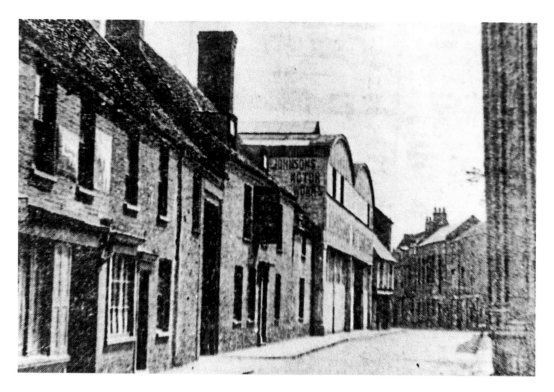

Church Street, Formerly Red Cow Street, c. 1930

Church Street was on the route from the South Gate, and the location of the Crown Inn described in 1728 as 'newly built'. It was taken down around 1925 as the motor works of W. H. Johnson & Sons expanded. Mann Egerton ran the garages from 1958, but transfer to modern premises led to the demolition of the Church Street buildings in 1990. Redevelopment schemes for housing and shops have failed to materialise and the site serves as another town centre car park.

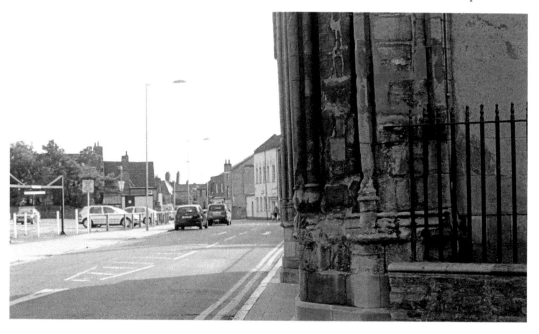

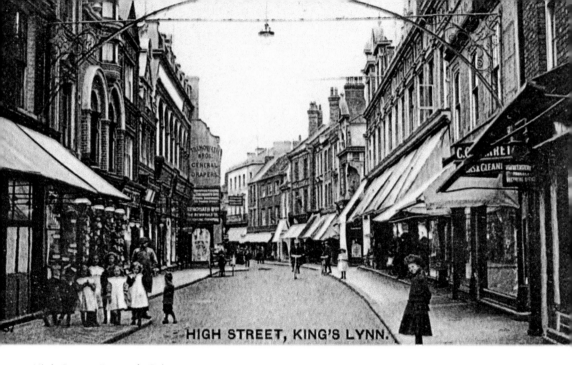

HIGH STREET, KING'S LYNN.

High Street, Formerly Briggate, c. 1910
Turning left from Church Street into the Saturday market place demands a glance down High Street. Until the late nineteenth century, it was the home of big tradesmen who were patronised by the middle classes. Then the retailing revolution began with the opening of Alfred Jermyn's department store in 1872, which was rebuilt in 1884 and 1897 after disastrous fires. It is the large premises on the right, and attracted a broad social spectrum. Jermyn's became Debenhams in 1943. The arches with decorated ironwork were gas pipes with street lamps that were removed in 1963, before High Street was pedestrianised in 1969.

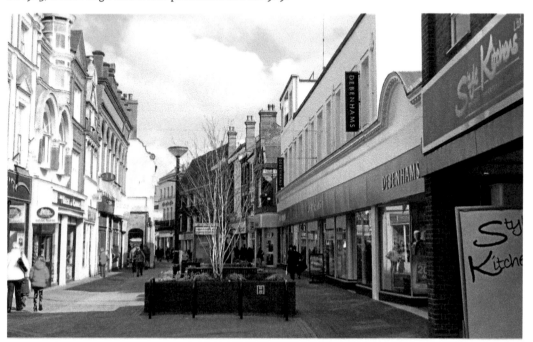

High Street and Saturday Market Place, *c.* 1908
This Edwardian postcard looks into the market place, showing the east end of the Georgian shambles used by butchers up to 1914. On the right is the fully licensed restaurant owned by Lizzie Wenn, who is listed in local directories in 1901 and 1908. It became a public house and continues to run as 'Wenns'.

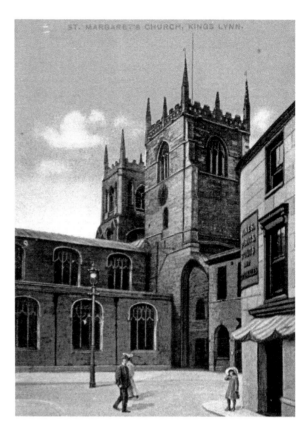

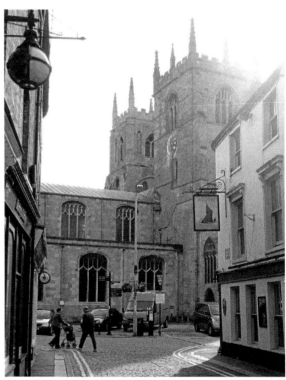

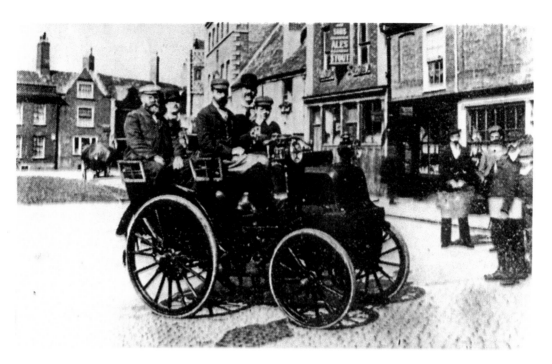

Saturday Market Place, c. 1898

The first motor car appeared in Lynn around 115 years ago and soon drew an amazed crowd. The owner was Mr Griffin, a Norwich dentist. Now motor cars pass this busy corner constantly without surprise or much notice. The building in the background is Wenns public house with eighteenth- and nineteenth-century ranges on the market place and High Street respectively.

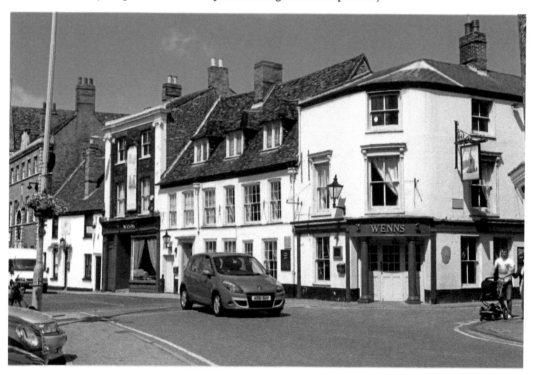

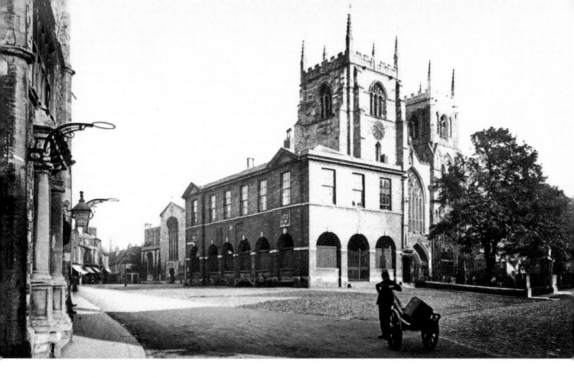

Lynn Minster, 1906

St Margaret's priory church or Lynn Minster has dominated the Saturday market place since 1100, and was rebuilt on a grander scale around 1220. The priory on its southern flank housed Benedictine monks until their expulsion in the 1530s during Henry VIII's Reformation. The medieval weekly markets and summer fair in the market place hugged the churchyard wall, against which shambles for butchers were built. The last such structure seen here was erected in 1779 and demolished in 1914.

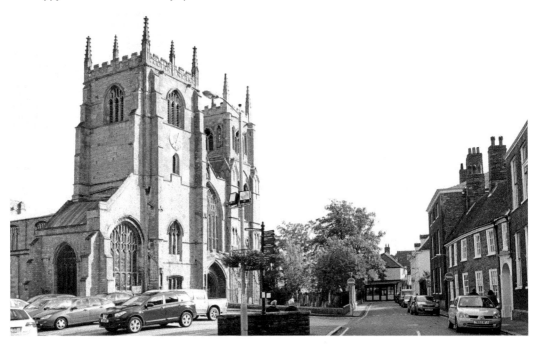

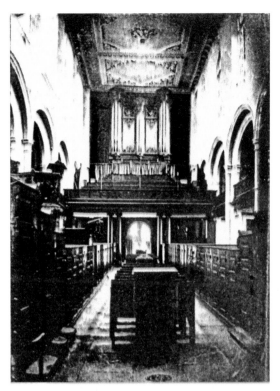

Inside Lynn Minster, 1874
The spire on the south-west tower crashed into the nave during a great gale on 8 September 1741 and destroyed a large part of it. Sir Robert Walpole and George III both gave £1,000 towards reconstruction. The new nave was completed by 1747 with an ornate stucco ceiling and galleries and the magnificent Snetzler organ above the west window. Scott's 'restoration' of 1875 involved the extraction of the Georgian interior in an attempt to return to the medieval church! Hence the appearance of the nave since then.

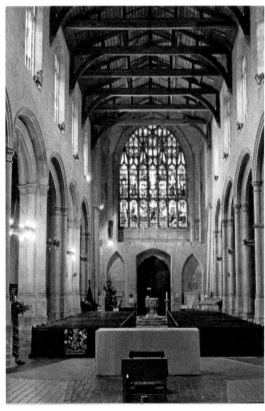

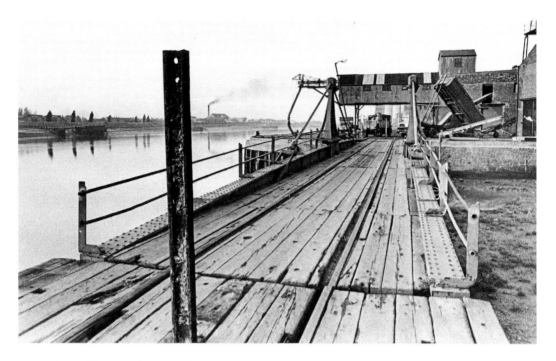

The Millfleet Bridge, c. 1969

In 1856, the swing bridge carried the harbour branch railway over the Millfleet onto the South Quay. It was demolished in 1970 and cars now access the riverside over a barrage built in 1988. Small boats like the ones shown in the inset were hence excluded from the fleet. Across the river can be seen the smoking chimney of Lin-Can, built in 1933 to preserve Fenland produce for markets at home and abroad. In 2004, all commercial operations on the South Quay ended when the grain silos erected in 1968 were closed.

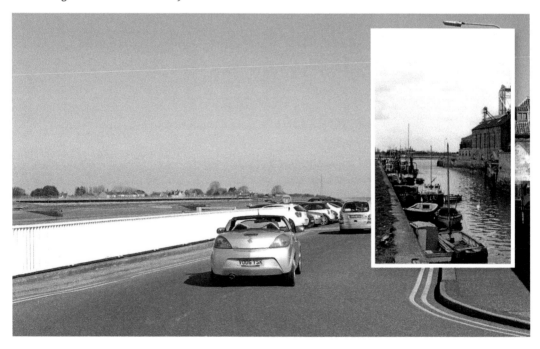

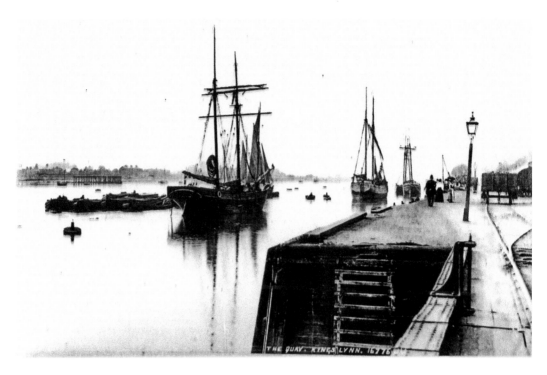

The South Quay, c. 1900

A view looking north along the quay constructed in the 1850s, showing river traffic and railway wagons as well as strollers (probably on a pleasant Sunday afternoon). It contrasts nicely with the same scene today. A regenerated South Quay has pontoons for leisure craft and was officially opened in August 2013.

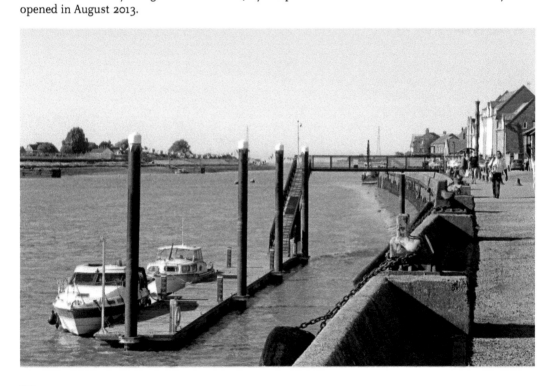

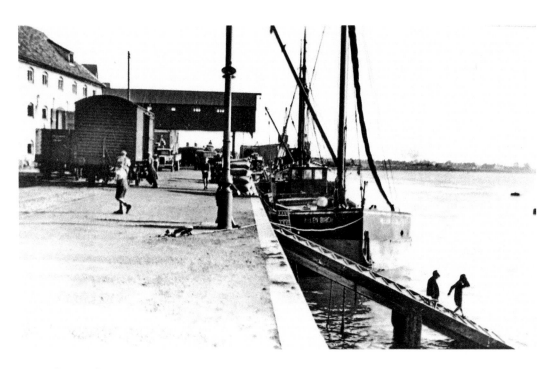

The South Quay, c. 1935

The South Quay looking south when still a busy area of the Port of Lynn. The eighteenth-century warehouse on the left belonged to Sommerfeld & Thomas. Since 2000, the South Quay has become attractive for both tourists and residents. On the left is Marriott's Warehouse, erected in the 1580s to store corn and salt, which is now the home of a Trust dedicated to promoting Lynn's exceptional historic built environment, with a restaurant run independently on the ground floor.

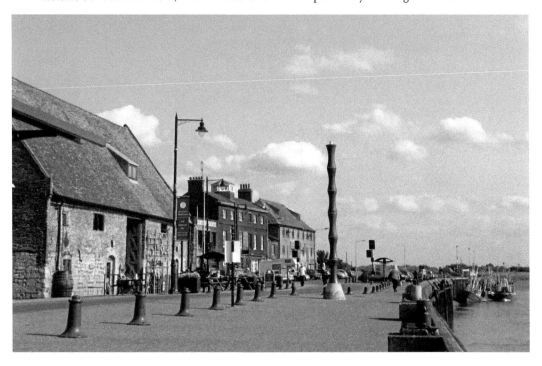

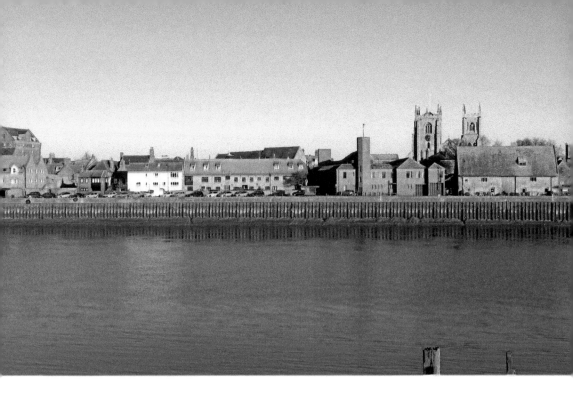

The South Quay From West Lynn, 2013

The twin towers of Lynn Minster watch over the Great Ouse as they have done for centuries, but in the last thirty years the South Quay has lost its merchant shipping and granaries.

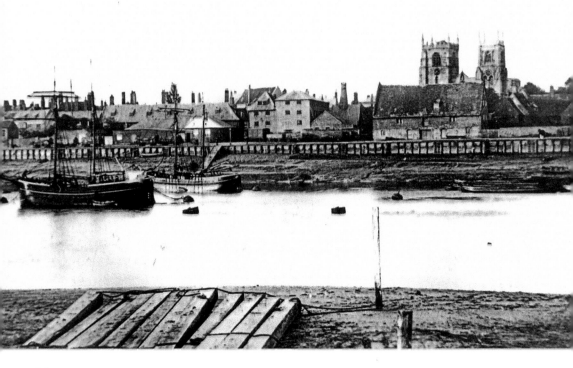

Clifton House and South Quay, c. 1990
An unusual view of Clifton House after
the demolition of warehouses for the
construction of Three Crowns House in
1993. The five-storey brick tower was
probably built in the 1570s by George
Walden, who would have entertained
merchant friends in its richly decorated
and heated rooms. It was also no doubt
a status symbol to impress townspeople,
as well as a look-out for ships.

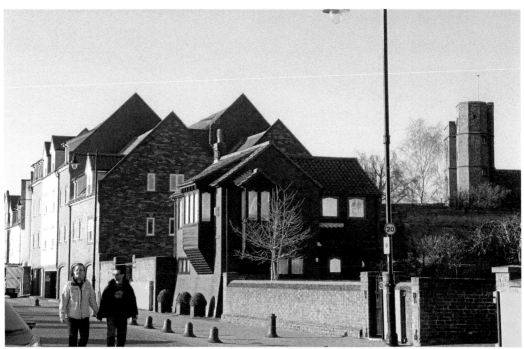

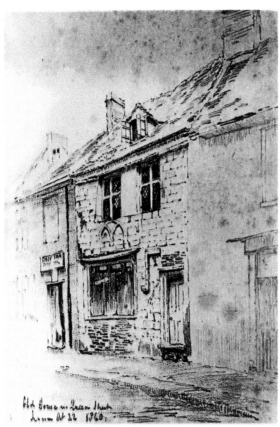

Old Houses, Queen Street, Formerly Wyngate, 1860

This drawing by Henry Baines shows a twelfth-century stone house that was tragically demolished in 1977. Next door was the Ship Inn, whose landlord in 1861 was a corn porter. It closed in 1911. The fall in the number of sailors in Lynn, as the steamer replaced the sailing ship, adversely affected its many riverside taverns. Other buildings in Queen Street were taken down in 1973, but its west side boasts some historic town houses.

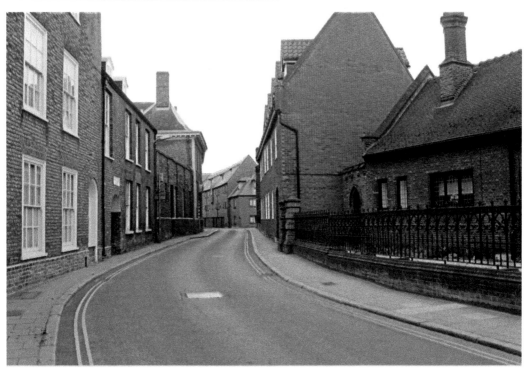

High Bridge From Purfleet Bridge, 1852

High Bridge spanned High Street with tenement buildings for the labouring poor overlooking the fleet itself. At low tide, the Purfleet was 'a horrible place' but the porters who loaded and unloaded ships washed themselves in its waters! In 1865/86, the High Bridge was demolished and the fleet beyond covered over for a wider New Conduit Street. Today the upper fleet looks very different, and a new pedestrian bridge was built at its eastern end in 2013.

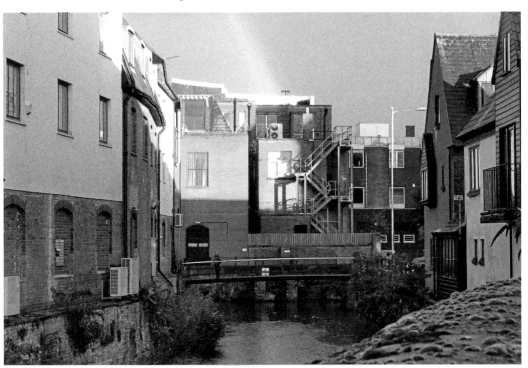

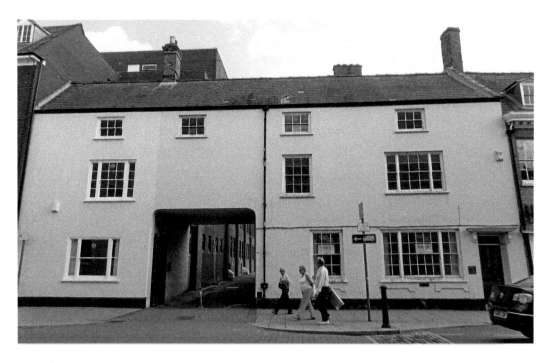

Bagge's Brewery, 2013 and c. 1920

From the 1690s to 1929, the Bagge family of Lynn merchants ran a brewery in King Street and the street range survives. The beer provisioned their coastal colliers and other ships before 1850, as well as tied public houses in West Norfolk. W. & T. Bagge sold the Lynn brewery and seventy-five tied taverns to Steward & Patteson of Norwich in 1929. The twenty workers on view were almost certainly sitting in its yard.

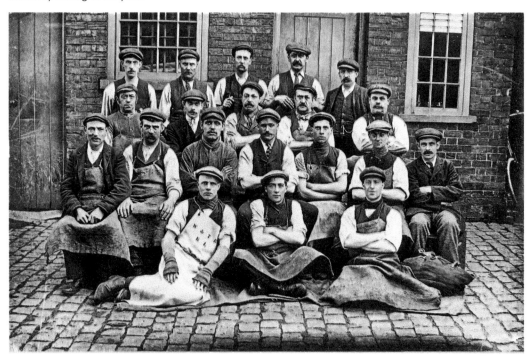

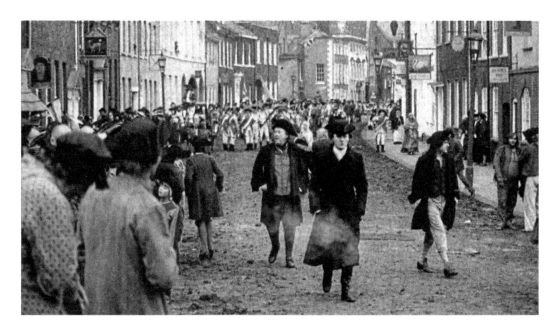

King Street and 'Revolution', 1985

King Street is Lynn's grandest historic thoroughfare. Extensive redevelopment in the eighteenth century meant its Georgian character was ideal for the setting of *Revolution*. This film was made in 1985, with Lynn portrayed as New York in the 1770s when the American colonists fought the British. Goldcrest Films employed Hugh Hudson as director and Al Pacino starred. For centuries the home of Lynn's principal merchant princes, King Street in the twentieth century attracted accountants, lawyers and estate agents, though pleasant private houses remain.

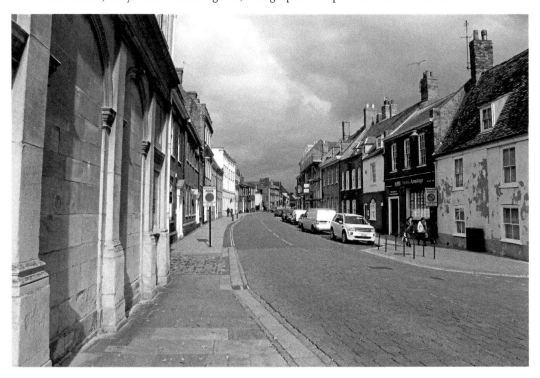

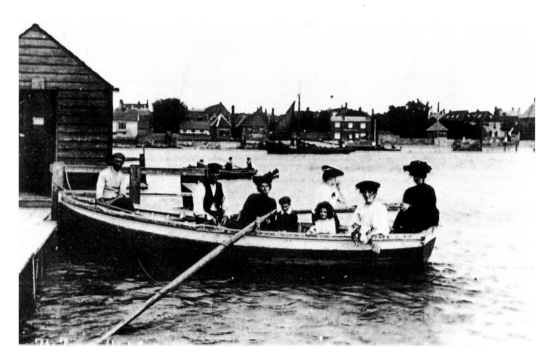

Lynn Ferry, c. 1910

The ferry boat was rowed from West Lynn and back for centuries, until 1920, when two petrol-driven motor vessels replaced it. Since 1989, Lynn Ferry has been in private hands, but with some public funding. It is a regular and important service for commuters, among others. Occasional leisure trips for the public up and down the river offer a splendid prospect of the historic town. St Peter's church at West Lynn can be seen.

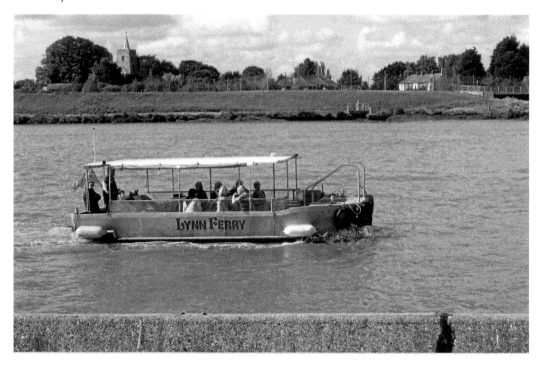

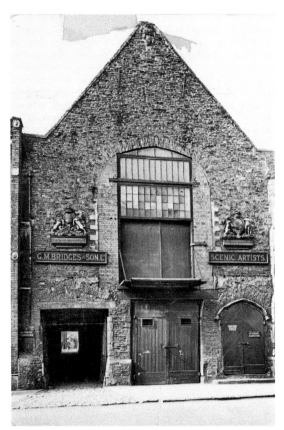

St George's Guildhall, King Street, Formerly Chequer Street, 1945
In 1945, this fifteenth-century merchant guildhall was in danger of demolition before Alexander Penrose purchased it. The restoration project resulted in its rebirth as a theatre and arts centre. Lady and Lord Fermoy had led the fundraising campaign. She was the driving force behind the first Lynn Festival of Music and the Arts in July 1951, when St George's Guildhall was opened by HM The Queen. The King's Lynn Arts Centre Trust is now managing the historic complex and promoting activities consistent with its mission.

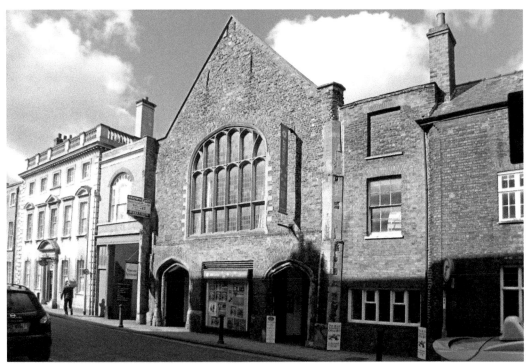

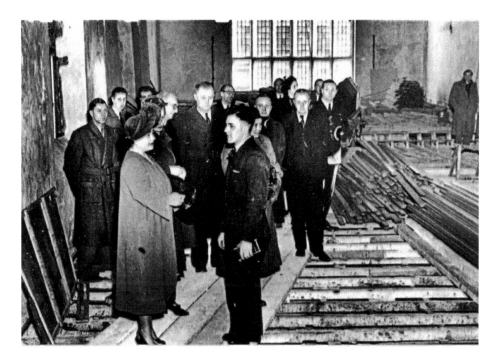

Inside St George's Guildhall, 1951

HM Queen Elizabeth showed a great interest in the restoration of the magnificent medieval hall as the project unfolded. Here she is seen talking to workmen on a visit in January 1951. Seven months later, the building was ready for the grand opening and its long association with drama restarted.

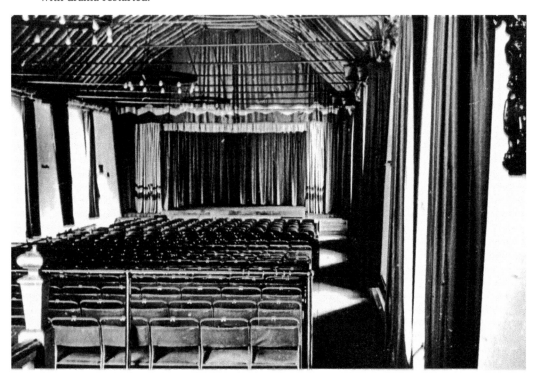

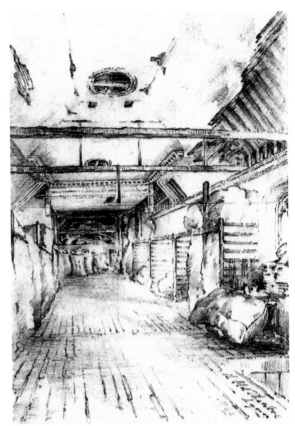

Inside St Georges Guildhall, 1860
The drawing by Henry Baines offers
a glimpse of the Elizabethan-style
theatre built inside the medieval hall
in 1766. Its six timber posts supported
a ceiling and stage, thrusting forward
towards the audience. After 1814, the
theatre became a wool warehouse
before being used by a firm of scenic
artists (G. M. Bridges & Son) in the
twentieth century. Its restoration in
1951 was widely applauded and plays,
concerts, lectures and films draw
good audiences.

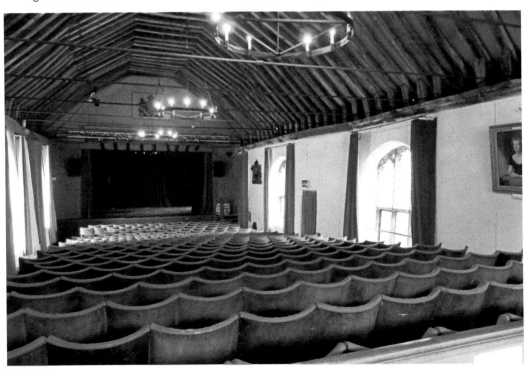

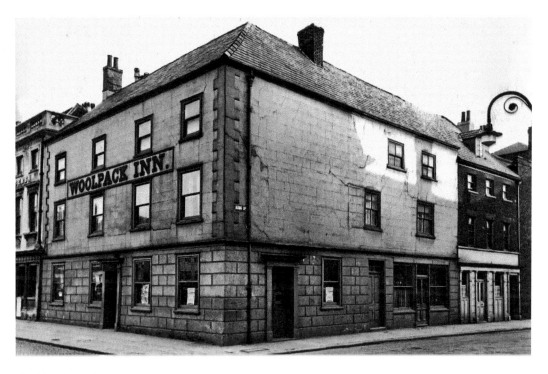

The Woolpack Inn, c. 1910

The Woolpack alehouse stood on this corner of the Tuesday market place in 1764, when wool was still traded in Lynn. In 1901, 'the tavern licensed victualler' was John Langley. On the right is the public house, The Exchange. The Woolpack Inn was deemed beyond repair by 1952 and rebuilt, but it had closed by November 2009, and is now a restaurant.

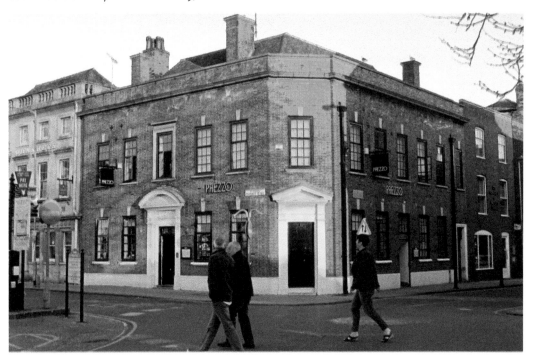

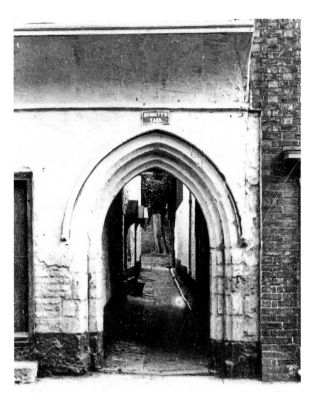

Bennett's Yard, St Nicholas Street,
Formerly Woolmarket, *c.* 1930
A large percentage of Lynn's
labouring population lived in
yards before the 1930s, when 'slum
clearances' led to resettlement in
suburban council estates. There
were two residents left here in
1934. The stone, arched doorway
belonged to a fifteenth-century
house that collapsed in a storm in
1952. It is currently isolated in a
historic street whose west side has
been demolished for car parking.

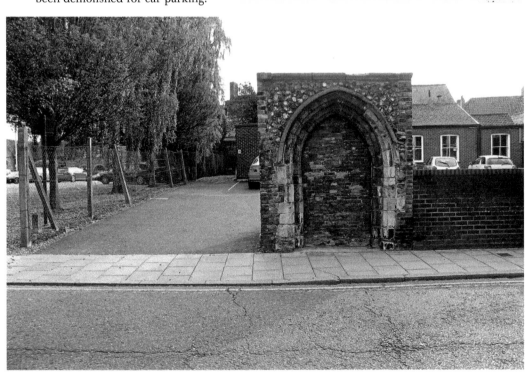

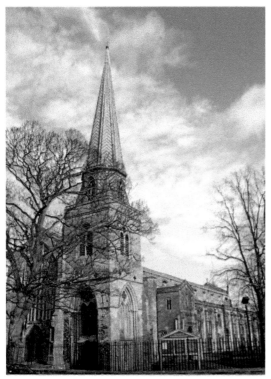

St Nicholas Chapel, St Ann's Street,
Formerly Northirne, 2013

Founded in around 1146 as a chapel of ease to St Margaret's priory church, and rebuilt in stone and brick around 1380–1420, St Nicholas is England's largest parochial chapel. It closed in 1989 and came under the protection of The Churches Conservation Trust (TCCT). In 2013, the Friends of St Nicholas chapel with TCCT raised sufficient funds to secure a Heritage Lottery Fund grant of £2.3 million. Roof repairs, a new heating system and modern facilities in the thirteenth-centuy tower are priorities in 2014. Already restored are the chapel doors, which were rededicated by the Bishop of Lynn in March 2013 in their medieval colours of red and green.

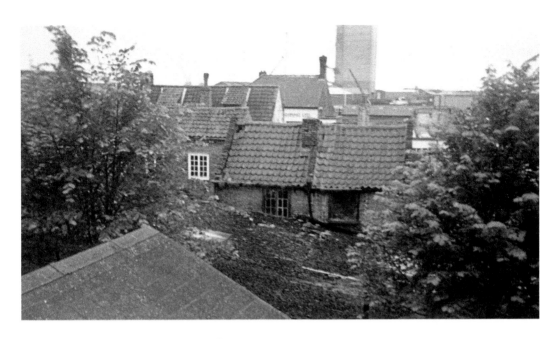

William True's Yard, *c.* 1983 and 2013

Pat Midgley saw these two old cottages from this viewpoint about 1983 and realised their significance: not all the yards in Lynn's historic fisherfolk quarter had disappeared! With a group of Northenders and supported by the borough council, she led a successful campaign to restore the cottages and the adjacent buildings on North Street. True's Yard Fisherfolk Museum was opened by HRH The Prince of Wales in 1993, and its first extension on St Ann's Street in 1998 by Sir Paul Getty. HM The Queen, accompanied by HRH Prince Philip, opened the second extension in 2010, which included the restoration of Lynn's last surviving smokehouse. The same outlook today shows the heart of a thriving community museum.

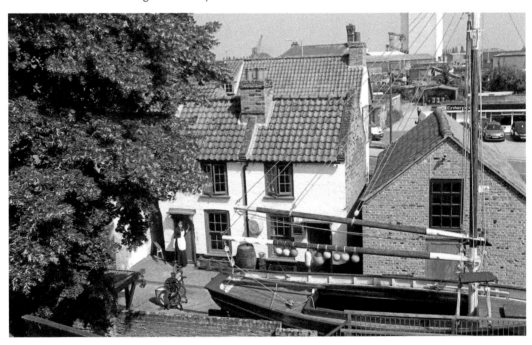

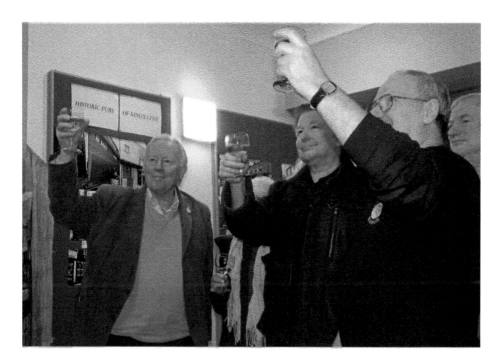

Celebrating John Barleycorn, 2013

The Naval Reserve was acquired by the North End Trust in 1994 to incorporate it into True's Yard Fisherfolk Museum. The public house opened in 1917, following the amalgamation of two Victorian alehouses. The former bar is now used as an exhibition and display gallery. The opening of an exhibition on Lynn's historic taverns in 2013 took place in the same room as the solo drinker around seventy years ago. Barleycorn, or the grain from which malt is made, is personified as John Barleycorn.

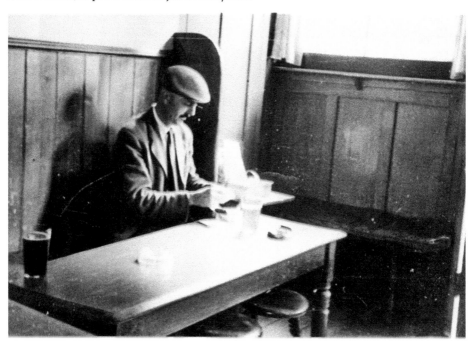

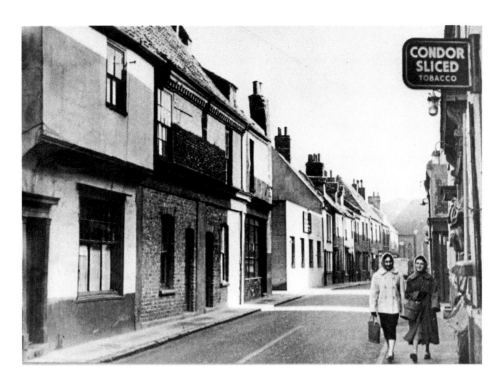

North Street, Formerly Dowshill Street, 1958

The earlier photograph (*courtesy Eastern Daily Press*) portrays old North Street. Its shops, pubs, bakehouses and smokehouses were hubs of the fisherfolk quarter for centuries. Several yards crammed with small houses were just off the street itself. In 1901, there were 102 residents in North Place, for example. The bulldozers arrived in 1958. The community was soon swept away so that the road could be widened, despite local opposition.

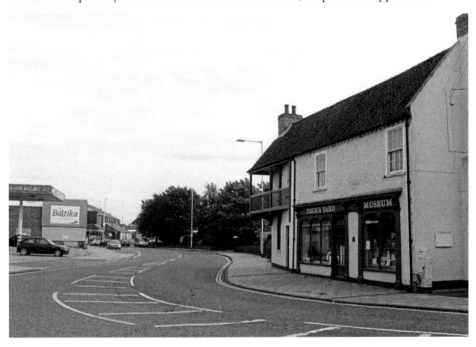

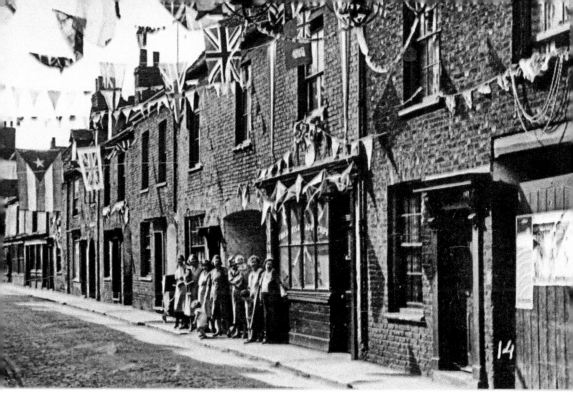

A Royalist Street, 1935

North Street looking west in 1935 as residents celebrate the Silver Jubilee of King George V. Just to their left is George Veal's fish and chip shop with the Whitening Yard behind. Patriotic feelings are highlighted by the street bunting. The significant number of East European migrants who have settled in Lynn is indicated by the European Food Store 'Baltika', which now occupies the site.

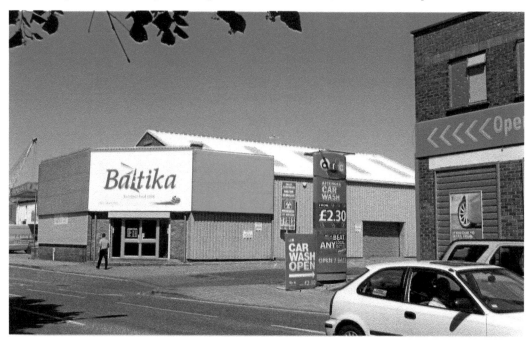

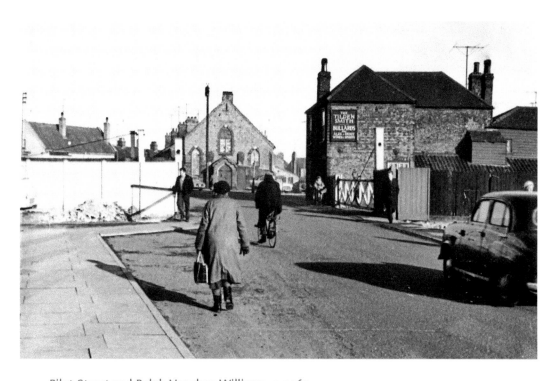

Pilot Street and Ralph Vaughan Williams, *c.* 1962

Central is the tavern called The Tilden Smith, before the name change to The Retreat in 1975. Here, in 1905, Ralph Vaughan Williams encountered the Lynn fisherfolk whose songs profoundly influenced his music. Duggie Carter's rendition of 'The Captain's Apprentice' made the strongest impression on the young composer. The public house displays a plaque to signify its cultural importance but, since 1960s redevelopment of the area, it is no longer in Pilot Street. It has recently closed.

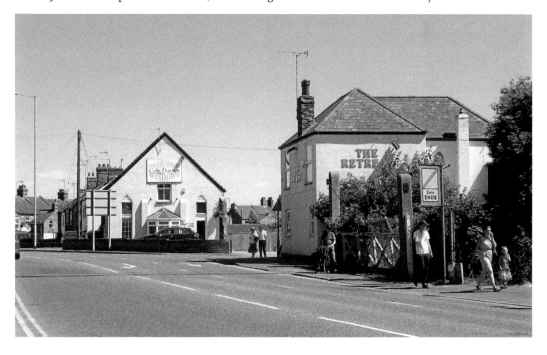

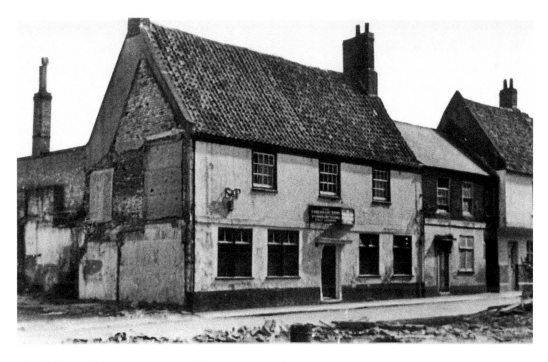

The Fisherman's Arms, a Community Centre, c. 1960

Another of Lynn's most famous taverns was in Pilot Street, often run by retired fishermen like 'Pluck' Howard (1916–28). Darts, dominoes, skittles and singing contests were all popular activities. It is listed as a town alehouse in the 1760s, but it was unfortunately demolished in the 1960s when Pilot Street was truncated to make John Kennedy Road. The site is now occupied by modern housing, but the ancient Grampus Inn on the right has survived.

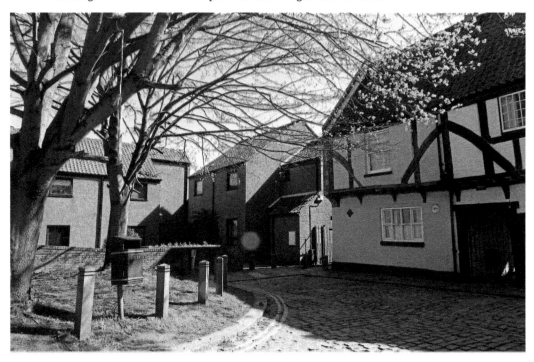

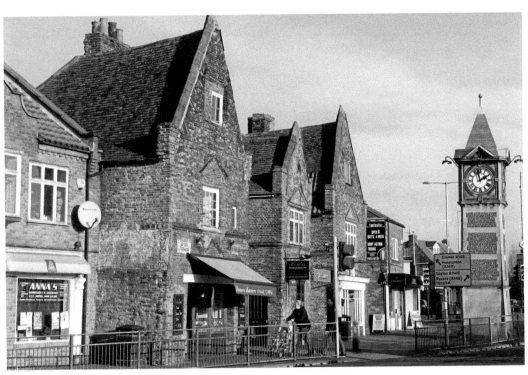

Gaywood Clock, 2013

The Gaywood Clock is mainly of carstone on a limestone base. It stands beside a large, early seventeenth-century house called Bishop's Terrace, having been moved from its original location nearby in around 1980. This prominent landmark was erected in 1920 by Gaywood's citizens in honour of the men from the village killed in the First World War (1914–18). It now commemorates the men and women who died through enemy action in both World Wars.

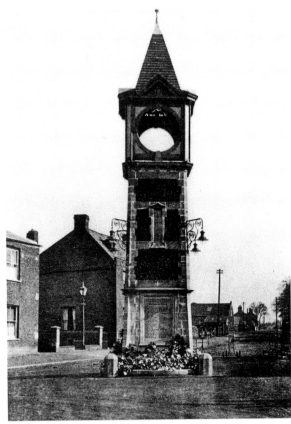

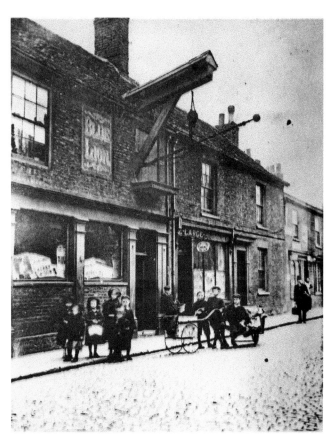

Blue Lion or 'Hanging Chains', Norfolk Street, Formerly Damgate, c. 1910

From Gaywood, the road back to the town centre leads due west to Norfolk Street, where The Blue Lion was once one among around sixteen public houses. It is listed in 1764 as the 'Blue Lyon Alehouse'. A weighing machine apparatus attached to the building included an arm projecting over the pavement to lift wagons onto an adjacent steelyard using chains. The gantry was dismantled in 1913 and the mechanism removed to the museum opened at the Greenland Fishery in Bridge Street. The public house closed in 1912.

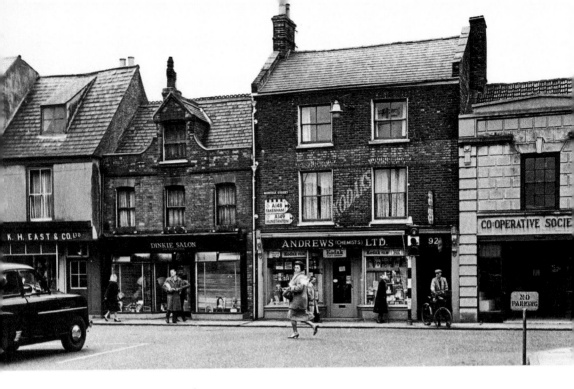

Townsend's Corner, *c. 1963*

Charles Townsend's shop on the corner of Norfolk Street and Railway Road (off photograph above to the left) sold seeds, bulbs, fruit and garden tools. This familiar Lynn T-junction was transformed in the early 1960s. To allow traffic direct access to the docks in the north of the town, that part of Norfolk Street facing Railway Road was demolished, and John Kennedy Road opened in December 1964.

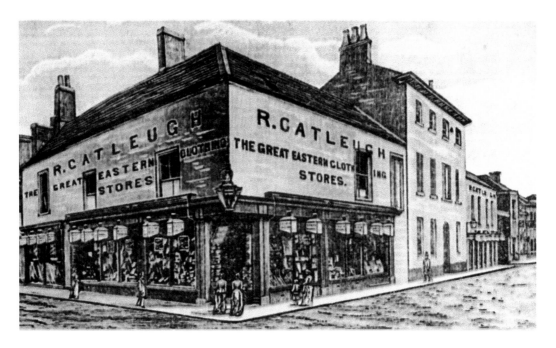

Catleugh's of Lynn, c. 1890

In 1882, Richard Catleugh moved his new drapery business from nearby Albert Street to larger premises on the corner of Norfolk Street and Broad Street. Success sprang from his good quality but inexpensive clothing 'suited to all classes' to merit the title 'Great Eastern Clothing Store'. Catleugh's of Lynn became a town institution but their famous corner store closed in 1981, having spent ninety-nine years on this site.

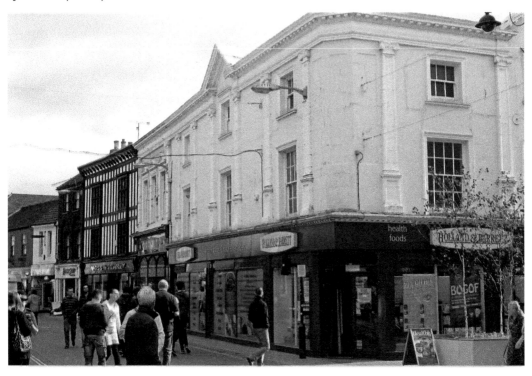

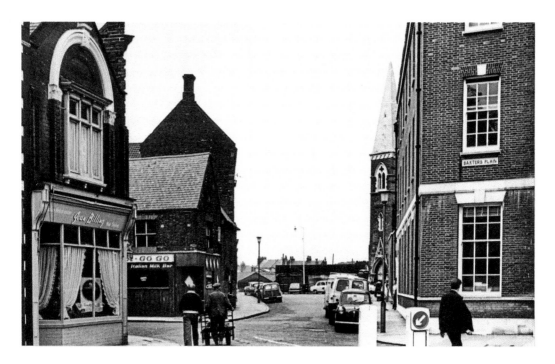

Baxter's Plain, 1962

Baxter's Plain is an historic urban space with five streets feeding into it. To the left is the Whisky a-Go-Go café, opened by 1962, having replaced two shops on the corner of Broad Street and Paradise Parade. It was immediately a magnet for Lynn's teenagers as the 1960s social revolution got underway. Lynn Museum is in the background; it was a Baptist Chapel converted in 1904. In the foreground is the General Post Office, built in neo-Georgian style in 1939. The GPO vacated the property for a town centre store in 2007, and there are currently plans to redevelop it for shops and flats.

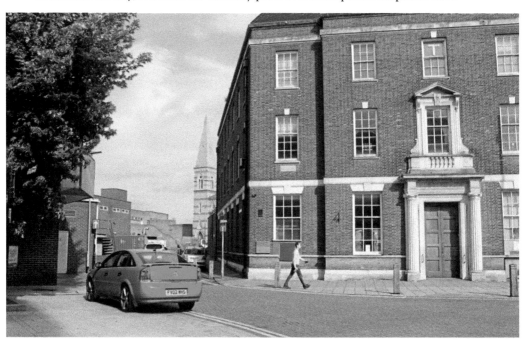

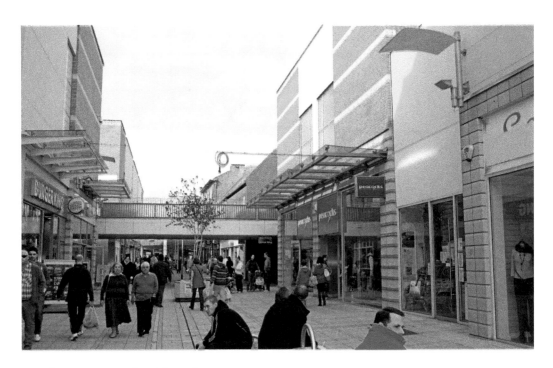

Broad Street, Formerly Webster Row, 2013
The street was rebuilt in the early 1970s as part of Lynn's new shopping centre, but was reconstructed again in the early twenty-first century. A dramatic change in the street scene has resulted. Old Broad Street accommodated local businesses. Taylor's garage (formerly a cinema), founded in 1933, is visible just beyond the entrance to the Cattle Market. The latter had moved from nearby Setch into Lynn in 1826, before relocating to the south of the town in 1971.

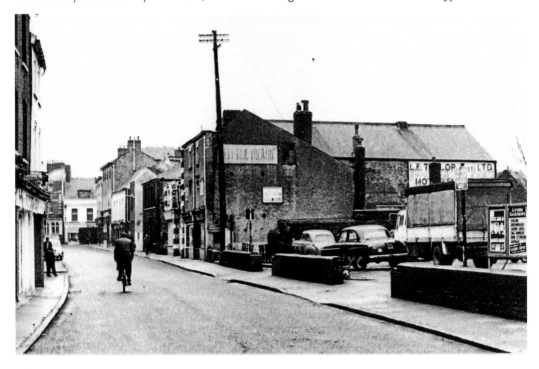

The Golden Ball and Majestic, 1929
This tavern in Tower Street was one of seventy-five tied houses sold by W. & T. Bagge to a Norwich brewery in 1929. In 1928, the Majestic Cinema next door was erected and the local newspaper claimed it was 'the last word in luxurious picture theatre' in the eastern counties and 'as good as any' in London. It is nice to report that it continues to serve as a popular town cinema.

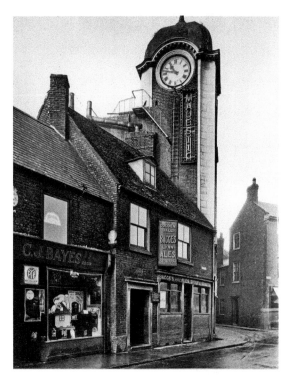

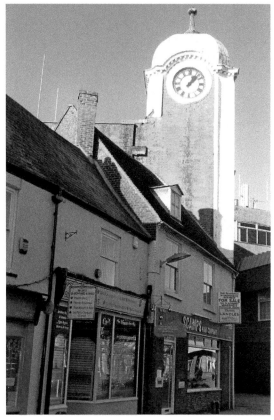

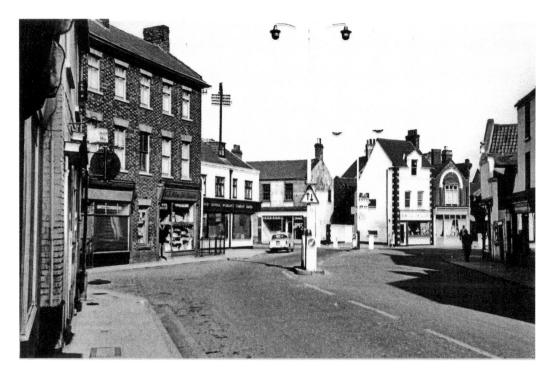

Tower Street, Formerly Baxter Row, c. 1960

The camera looks north into Baxter's Plain on what was probably a Sunday. The view has been transformed by redevelopment in the 1960s and later. Tower Street is pedestrianised with a pleasing variety of small businesses and shops. Its medieval name was Baxter's Row, or home of the baxters or bakers.

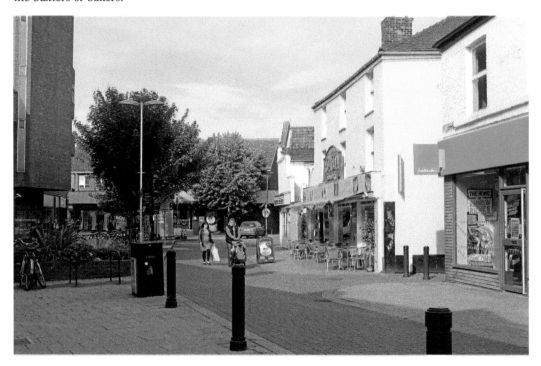

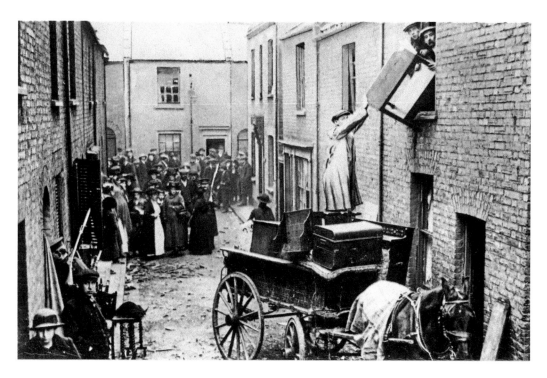

Bentinck Street and the Great War, 1915

'England bombarded from the Air', declared the *Daily Mirror* on 21 January 1915. Lynn had been the target of a German airship on 19 January! In Bentinck Street, two houses were demolished and two people killed during the Zeppelin raid. This apparently unique event in the annals of war attracted sightseers and enraged townspeople. The area once occupied by these working-class streets has been taken over by a swimming pool and a multi-storey car park.

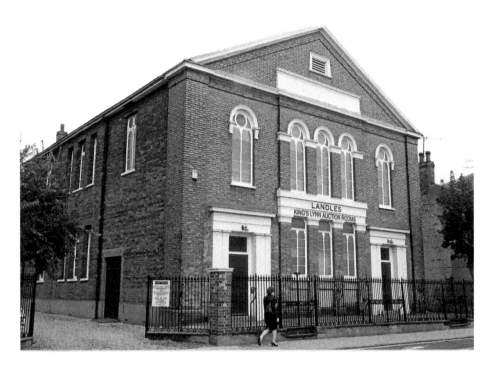

Stepney Baptist Church, Blackfriars Street, 2013

This handsome classical building opened in 1841, and one Sunday in June around 1,500 people were 'literally crammed' inside and twenty-one 'converted or decided for Christ'. Successful Lynn tradesmen and their families were prominent in the congregation. Today, the former church is Landles' King's Lynn Auction Rooms. When the Baptists left the building in 1983 for the Union Chapel at South Lynn, its future was a concern for local historians and conservationists, who are visible in the picture below inspecting the interior.

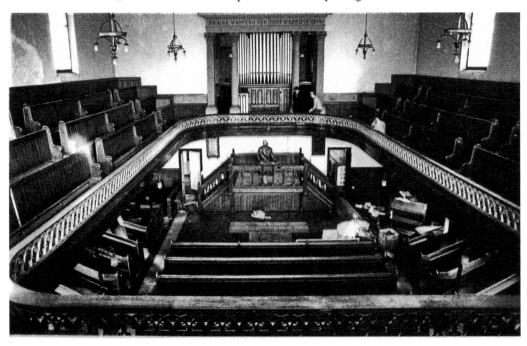

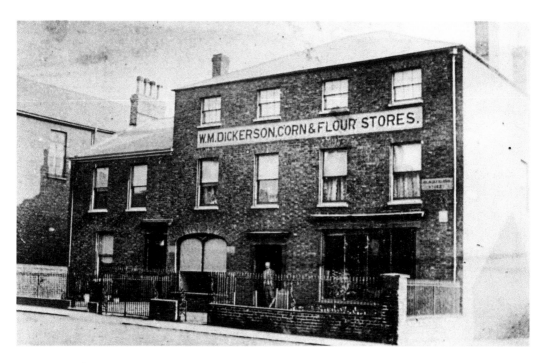

Steven's Corner, c. 1900

William and Fountain Dickerson were corn and flour dealers at the corner of Blackfriars Street and Railway Road. By 1916, the premises were occupied by Sam Stevens & Son, fishmongers, and this Lynn location became known as 'Steven's Corner'. Their shop closed about 1953. Since 1965, the property has been the home of Geoffrey Collings & Co. In 1947, Steven's Corner was selected for Lynn's first set of traffic lights, replacing a memorial horse trough. A sign of the times!

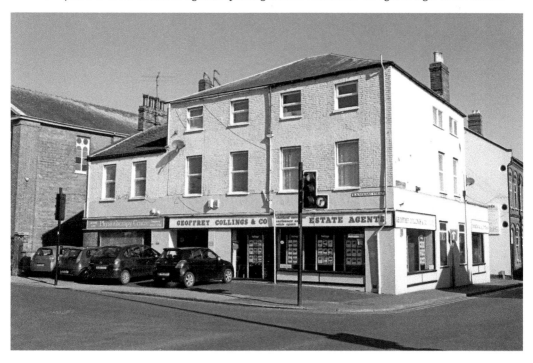

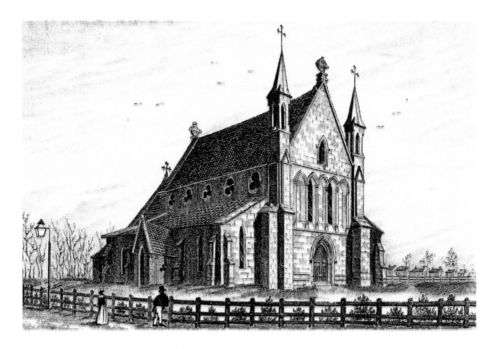

St John's Church, Blackfriars Road, 1848

To keep up with Lynn's population growth in the nineteenth century, the Anglicans built St John the Evangelist. The cost of over £6,000 came mainly from a Parliamentary grant and local subscriptions. St John's was consecrated in 1846 and known as 'the Poor Man's Church' because the majority of its 1,004 sittings were free. The English Gothic architecture reflected the fascination of many Tories and Anglicans for the Middle Ages. To stabilise the building, flying buttresses were added to the west end in 1889. Though St John's sits beside a busy road today, it doubtless remains an oasis of peace for its congregation.

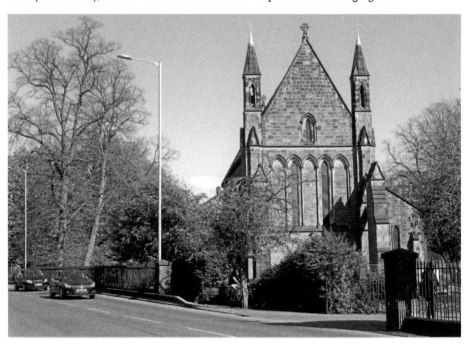

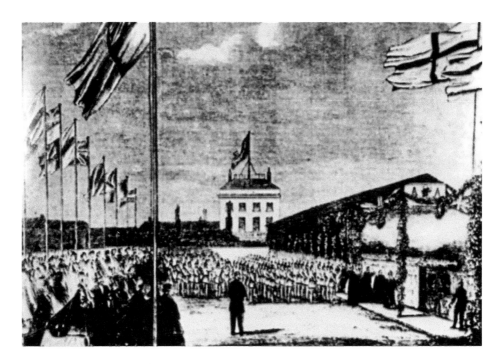

Lynn Joins England's Railway Mania, 1863

The town's first station was constructed in wood off Blackfriars Road for £1,800 in 1846. The drawing shows the Prince and Princess of Wales arriving in Lynn in 1863 en route to Sandringham to begin the rebuilding of their Norfolk home. The station was rebuilt in brick in a 'vaguely' classical style in 1872. The electrification of the line between Lynn and Ely in 1992 ensured that the town would retain it.

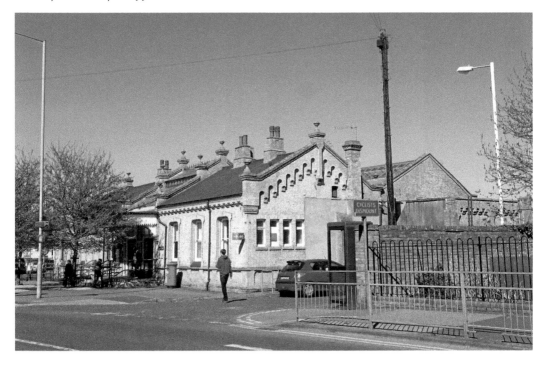

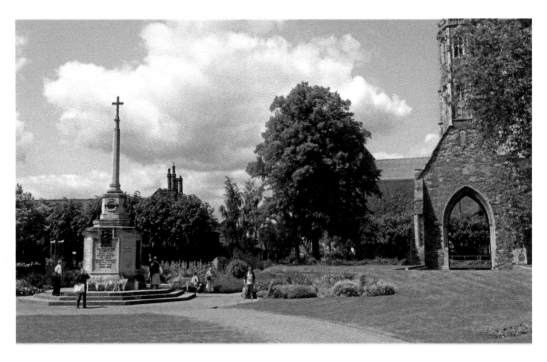

Lynn's Medieval Tower, 2013

Of the remains of Lynn's four medieval friaries, the central tower of the Franciscan church, built in brick around 1400, is the most imposing. It escaped demolition in the Henrician Reformation of the 1530s because of its usefulness as a seamark. This ancient monument was restored by the borough council, largely with assistance from the Heritage Lottery Fund in 2006. The area around it was reserved for grazing animals but converted into formal gardens in 1911 to mark the Coronation of George V. The war memorial was unveiled by Princess Mary in 1921 as a tribute to the Lynn men who fell during the First World War.

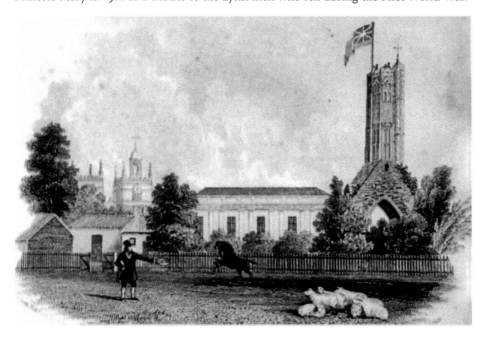

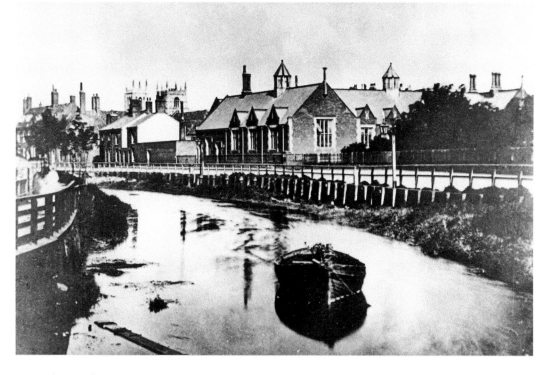

The Millfleet, Formerly Sunolf's Fleet, c. 1890 and c. 1930

This ancient waterway divides the parishes of St Margaret's and South Lynn, with its name deriving from the tidal mill once astride it. The polluted fleet was regarded as a health hazard and covered over after a town referendum tested public opinion in 1896. The Millfleet became Lynn's first bus station post 1918 until 1971, when it was relocated to the town centre. St Margaret's National School, built in Tudor Gothic style in 1849, is on the right.

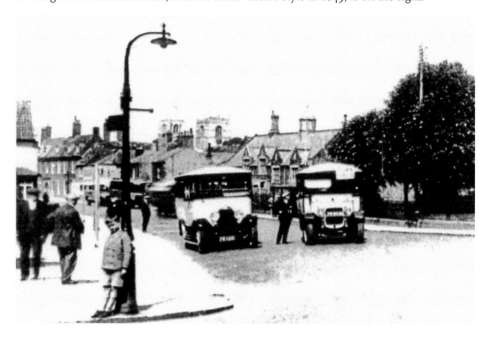

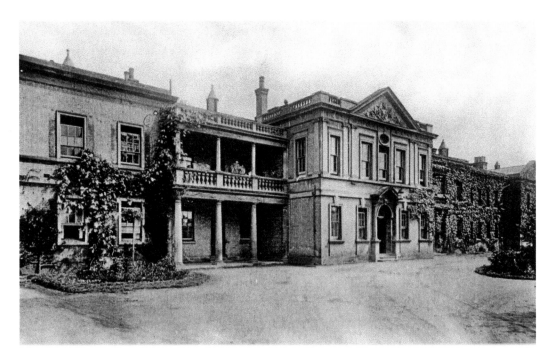

Lynn's General Hospital, c. 1930

To safeguard the public health, West Norfolk gentry assisted the founding of the hospital off London Road. It was opened in 1835 and cost £2,000. This yellow-brick classical building was enlarged by extensions in 1848 and 1852, but closed in 1980 and demolished. The new Queen Elizabeth Hospital had been constructed on the eastern outskirts of the town. The modern building on the site of the old hospital is an adult learning disability unit, opened in 1989.

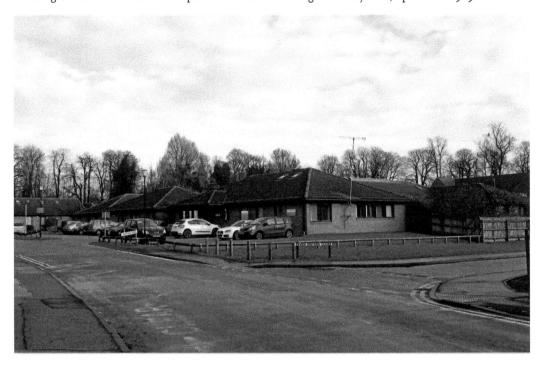

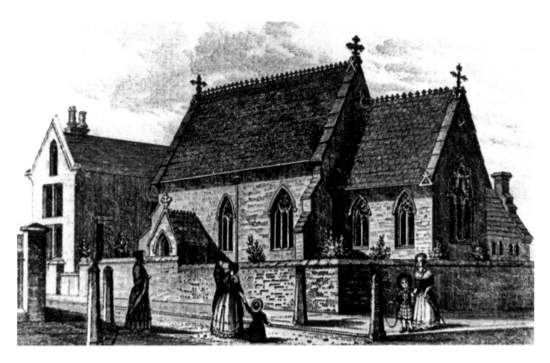

St Mary's Roman Catholic Church, c. 1870

A church for Lynn's Roman Catholics was built on London Road to a design by Pugin and opened in 1845. Faulty foundations resulted in a rebuilding of the church in 1897 through the efforts of Father Wrigglesworth. He created a single-storey shrine on the north aisle, a replica of the Holy House at Loreto, with a statue of Our Lady blessed by Pope Leo XIII. From 1897 to 1934, this was the official shrine of Our Lady of Walsingham. Father Wrigglesworth also restarted the pilgrimage from Lynn to Walsingham in 1897.

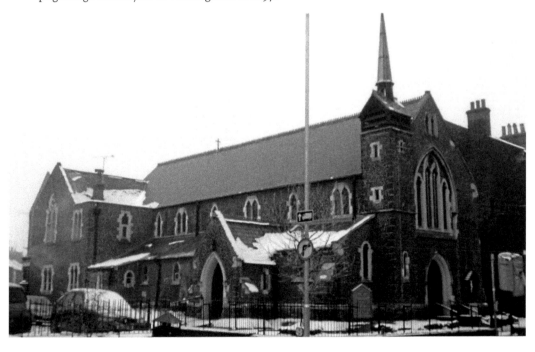

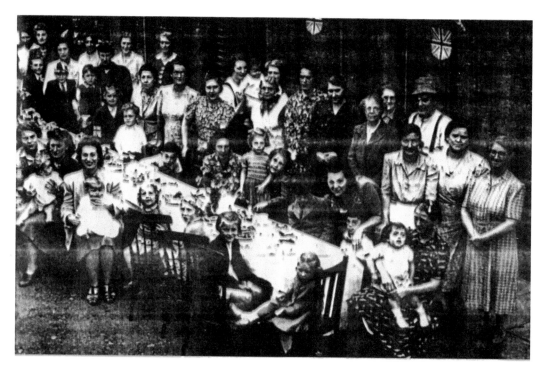

Checker Street, 1945

Checker Street was built in the 1840s. It was a close-knit community in 1945 when its residents celebrated VE Day in May. The children's feast is overseen by mothers and grandmothers in this patriotic gathering as the Second World War in Europe ended. Checker Street retains its Victorian character, though often crowded with motor cars as other historic town thoroughfares.

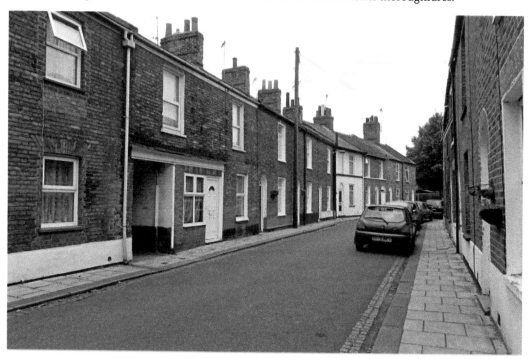

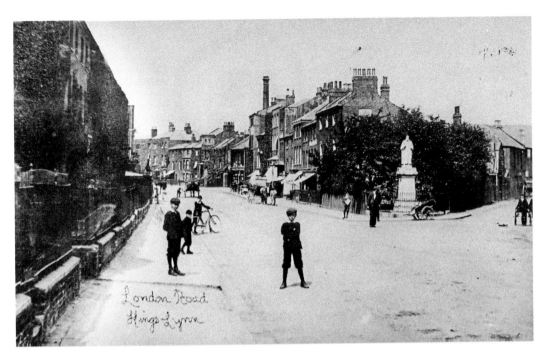

London Road, Formerly Hen Walk, c. 1900

Just inside the medieval South Gate, this view depicts London Road looking north, Lynn's first bypass built up with housing from the 1820s. It lost its fashionable status over the course of the twentieth century as more of the town's business and professional people resettled in the suburbs or nearby villages. Since 1892, travellers entering the town via the South Gate have been greeted by Frederick Savage, Lynn's famous Victorian industrialist, whose statue is prominent.

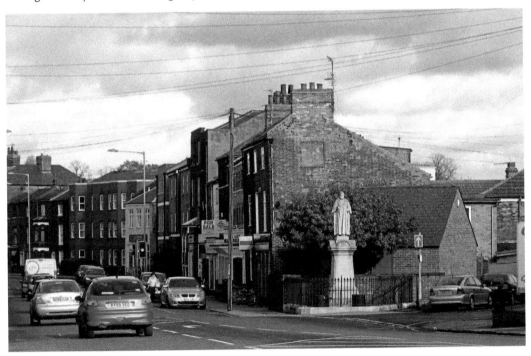

Acknowledgements

True's Yard Fisherfolk Museum has a large collection of old photographs of Lynn from which the majority of those appearing in this book spring. The author thanks his fellow trustees for permission to use them. Space does not allow full recognition of other contributors but he is grateful to those Lynn citizens who have generously offered old photographs or assisted his research.

Paul Richards wishes to record his special appreciation to Richard Flowers, who has been a willing and diligent cameraman throughout 2013. The Market House Photography Group from Long Sutton took some of the photographs in the book, which have inevitably enhanced it. Lindsey Bavin (True's Yard Fisherfolk Museum) has also been most helpful. Last but far from least the author thanks his wife, Alison, for typing the captions and undertaking other important tasks.

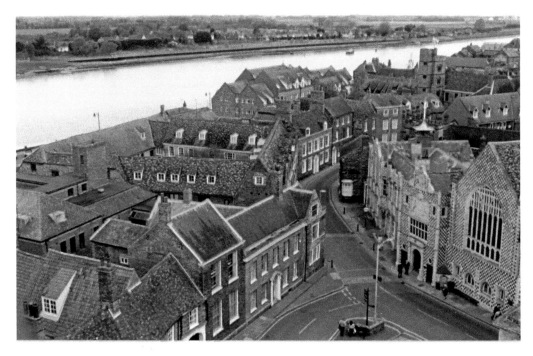

Lynn, 2013
This aerial view from the south-west tower of Lynn Minster shows part of the old town where Lynn's origins around 1100 can be discovered. Here is the Saturday market place and the Holy Trinity Guildhall. The River Great Ouse gave Lynn's merchants access to England's inland counties, as well as the North Sea and Europe. The advent of the railways in the 1840s and phases of industrialisation thereafter have reshaped the town, but its maritime character persists.